THE ART OF

DOODLE

WORDS

TURN YOUR EVERYDAY DOODLES INTO CUTE HAND LETTERING!

SARAH ALBERTO, CREATOR OF

Race Point
PUBLISHING

For Kris, Kyle, and Kara.

Brimming with creative inspiration, how-to projects, and useful information to enrich your everyday life, Quarto Knows is a favorite destination for those pursuing their interests and passions. Visit our site and dig deeper with our books into your area of interest: Quarto Creates, Quarto Cooks, Quarto Homes, Quarto Lives, Quarto Drives, Quarto Explores, Quarto Gifts, or Quarto Kids.

© 2018 by Sarah Alberto

First published in 2018 by Race Point, an imprint of The Quarto Group, 142 West 36th Street, 4th Floor, New York, NY 10018, USA

T (212) 779-4972 F (212) 779-6058 www.QuartoKnows.com

All rights reserved. No part of this book may be reproduced in any form without written permission of the copyright owners. All images in this book have been reproduced with the knowledge and prior consent of the artists concerned, and no responsibility is accepted by producer, publisher, or printer for any infringement of copyright or otherwise, arising from the contents of this publication. Every effort has been made to ensure that credits accurately comply with information supplied. We apologize for any inaccuracies that may have occurred and will resolve inaccurate or missing information in a subsequent reprinting of the book.

Race Point titles are also available at discount for retail, wholesale, promotional, and bulk purchase. For details, contact the Special Sales Manager by email at specialsales@quarto.com or by mail at The Quarto Group, Attn: Special Sales Manager, 401 Second Avenue North, Suite 310, Minneapolis, MN 55401, USA.

10 9 8 7 6 5 4 3 2

ISBN: 978-1-63106-528-6

Editorial Director: Jeannine Dillon
Managing and Project Editor: Erin Canning
Cover and Interior Design: Melissa Gerber

Printed in China

CONTENTS

· INTRODUCTION ·

HI!

MY NAME IS SARAH. I'm a doodle artist and stay-at-home mum from Sydney, Australia. Art has always been a part of me. Ever since I was young, I loved to draw but I never took any classes or attended art school. I only considered drawing a hobby, but I dreamed of becoming an artist and creating my own comic book one day. One of my biggest art inspirations and influences came from watching Japanese anime. Growing up, I also enjoyed reading about superheroes and characters in fantasy novels. I loved looking at different artists' styles and approaches, but that was where it stopped. I never thought of pursuing art as a career. It wasn't until I had my first child that my interest in art was rekindled as a way to relax while being a new mum.

With the birth of my son, I wanted to hold on to the memories of his childhood, and, naturally, I was fascinated with planners, journals, and scrapbooking. I became a member of the planner community on Instagram. I finally found my calling when I started to make little doodles for the pages of my planners because I couldn't afford to buy the stickers or stamps to decorate them. A surprising number of people seemed to like what I was doing and asked me to post more doodles. From there, I decided to create my YouTube channel, Doodles by Sarah, to share my ideas and creativity.

I started by making simple doodle tutorials as real-time videos so that people could doodle along with me. As the years went by, my community kept growing and viewers asked me to do calligraphy tutorials too. But calligraphy is one of my big frustrations. I can draw, but I can't do stylish, sophisticated handwriting. It's just one of those things I can't seem to get the hang of. I didn't give up though. I realized I could do hand lettering in my own style, and just like that, my Doodle Words videos were born.

Doodle Words combine drawings with words. It's a playful process for adding visuals or images to text to make it more interesting and eye-catching. The images you use are not just random but are associated with what you're writing. Each doodle represents something about the words.

In this book, I'll share with you my techniques for turning words into doodles. I'll take you through the basics of lettering, creating different letting styles, and ways to decorate and add detail. You don't need anything fancy to start working on your own doodle words. All you need is your favorite pen, some paper, and your imagination.

FINE LINER PEN

One of my must-haves when doodling is a fine liner pen. For the projects in this book, I used one of my favorite pens, the Staedtler Pigment Liner, but you don't have to use the same pen I do. I always say to use a pen you are comfortable with. Choose fine liners that are pigmented, water-resistant, and fade-proof, so you can preserve your artwork. Fine liners also come in different nib sizes. Use these nibs for making different line weights—thick and thin—in your doodles.

ERASABLE PENCIL

If you are not too keen on starting your doodles with a pen, don't hesitate to doodle with a pencil first—that way you can easily erase your mistakes and start over. I love using colored erasable pencils—the line seems cleaner and the lead is softer than a standard graphite pencil, making it easier to erase. For this book, I used a red Crayola erasable pencil for all the doodle words I created.

DUST-FREE ERASER

You'll find it helpful to use an eraser that doesn't leave behind dust or "crumbs" that you have to brush off your drawing. The black Faber-Castell Dust-Free Eraser is by far the best eraser I have ever used. It works well with any pencil—especially erasable color pencil—and it's one of my trusty tools when I make my doodles. After outlining my doodle words with a fine liner, I erase all the original pencil lines, and an eraser like this makes the job easier.

MARKERS

There is such a variety of color markers available. You'll find your favorites to color in your doodles, but the Stabilo Pen 68 is one of mine. It has a 1.0 mm nib that I like to use, especially when coloring in my faux calligraphy.

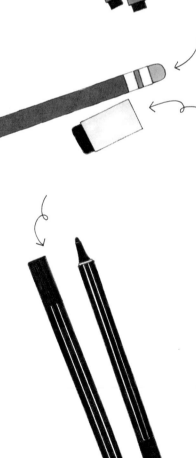

WHEN IN DOUBT, USE A PENCIL

Pencils are your best friend when doodling. When you are unsure of the design as you start out or you make a mistake, with a pencil, you can just erase it and start over again. Actually, I recommend that you first draw in pencil and then go over your word art with a fine liner. In a lot of projects in this book, I instruct to create impermanent templates (see below) to help guide your doodles.

CREATE TEMPLATES

Throughout this book I suggest that you make templates (in pencil). A template is a rough draft of your art. It will help you figure out the position of each element and how big or small you want your words to be. If you plan on making big, wide, or heavy lettering, remember to add a little space between the letters.

PABLO PICASSO

START WITH SKELETONS

A skeleton is the simple handwriting that you do before adding weight, thickness, detail, and decoration to your letters. A skeleton allows you to work out the spacing between letters and forms the foundation of all hand lettering.

USE YOUR IMAGINATION

The key to making your own doodle words is IMAGINATION. Use it when you're sketching and doing your visual note-taking. It will help you think up doodles associated with words, turn a letter into a pictorial shape, and add simple details that can make a big difference. Play around and experiment with your favorite words and phrases.

HAVE FUN

Doodles are not meant to be perfect. Doodling and coloring should be relaxing and help you de-stress. Sometimes your best work appears when you make mistakes. I like the wonky shapes and lines that aren't quite straight that show up in my work—they give character to my word art.

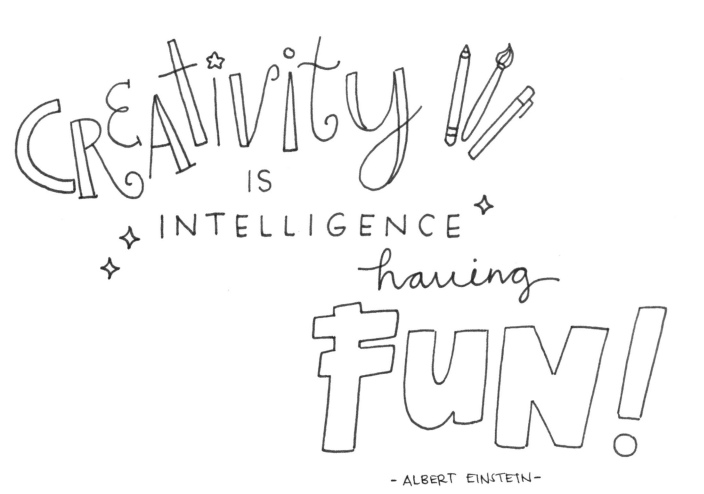

CREATIVITY IS INTELLIGENCE having FUN!

– ALBERT EINSTEIN –

PART I

DOODLE LETTERS

Use any combination of upper- and lowercase letter forms of this basic style in your doodles.

Aa Bb Cc Dd Ee Ff
Gg Hh Ii Jj Kk Ll
Mm Nn Oo Pp Qq
Rr Ss Tt Uu Vv
Ww Xx Yy Zz

Even the simplest lettering can be made fun and artistic with small additions. Use your imagination and play!

Ball-jointed

Dear Diary

SLANTED

BAD DAY

STITCHES

AUTOMATIC

Adding a line of cursive lettering in a doodled phrase can add emphasis or a sense of playfulness.

Aa Bb Cc Dd Ee

Ff Gg Hh Ii Jj

Kk Ll Mm Nn Oo

Pp Rr Ss Tt Uu

Vv Ww Xx Yy Zz

One of the things that's fun about cursive is that it can form part of the drawing itself.

always wear your invisible crown

My block letters start out as simple handwriting (page 12) in pencil. Then I outline each letter to create the block shape and erase the original pencil lines.

Look what fun you can have emphasizing the meaning of a word by drawing with block letters.

• THIN BLOCK LETTERING •

You won't always want a chunky style when you use block lettering. Block letters can be tall and thin too.

There are lots of ways to give thin block letters extra dimension.

The serifs (page 30), or little tails at the top and bottom of the letters, add extra style.

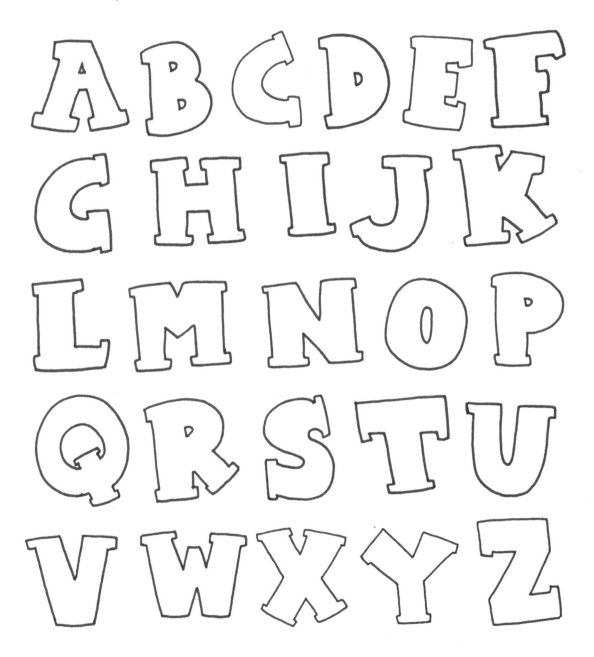

The great thing about block serif lettering is that the extra strokes give you lots of room for drawing in decorative elements.

· BUBBLE LETTERING ·

Drawing bubble letters is just like drawing block letters (page 16), but make your shapes pillowy and round the corners.

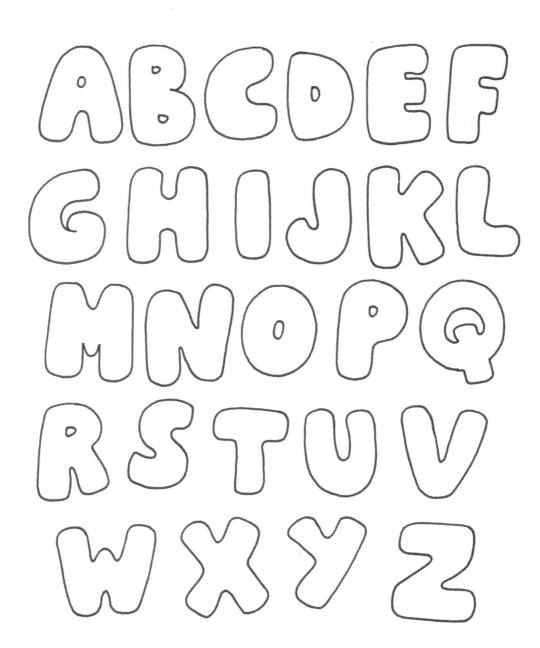

It's fun to emphasize the soft, fluffy, and rubbery elements of bubble letters when you use them for particular words.

Overlapping letters are like block letters (page 16); the difference is that you treat each vertical and horizontal element as a separate piece that lies on top or underneath of the next.

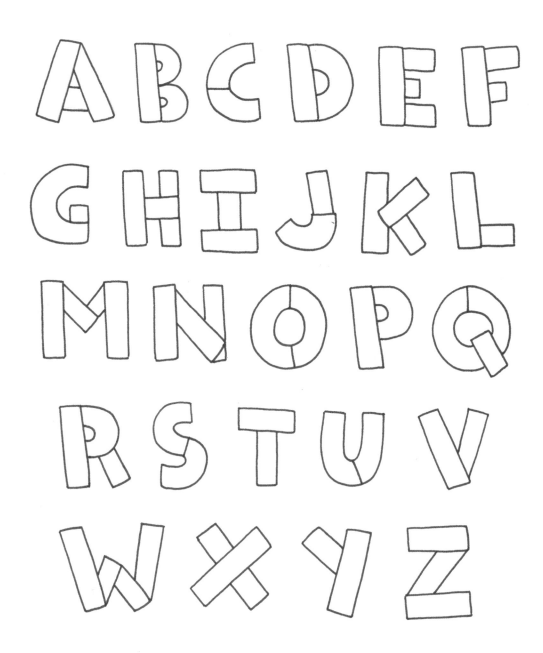

Look how much fun you can have with overlapping letters. Add details that help tell the story!

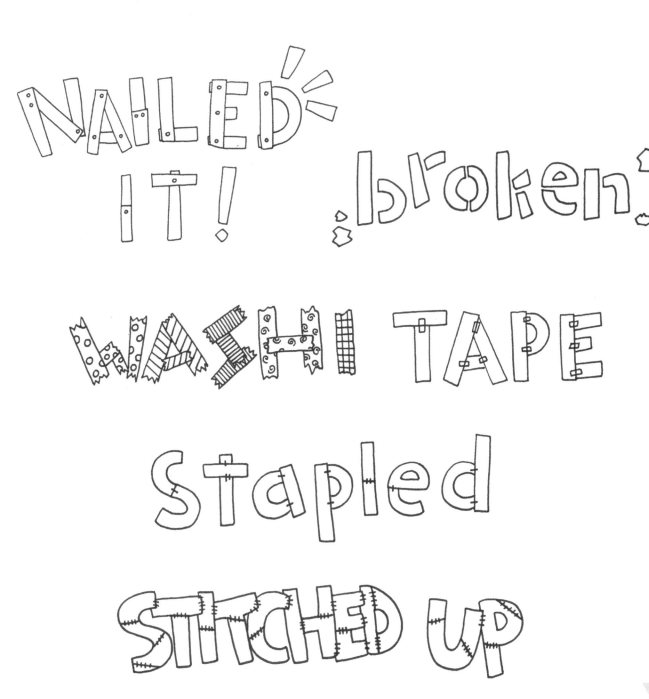

. PILLAR LETTERING .

To create pillar lettering, simply add a second line to the upright strokes of simple handwriting (page 12). The thick and thin elements in the letters make them playful.

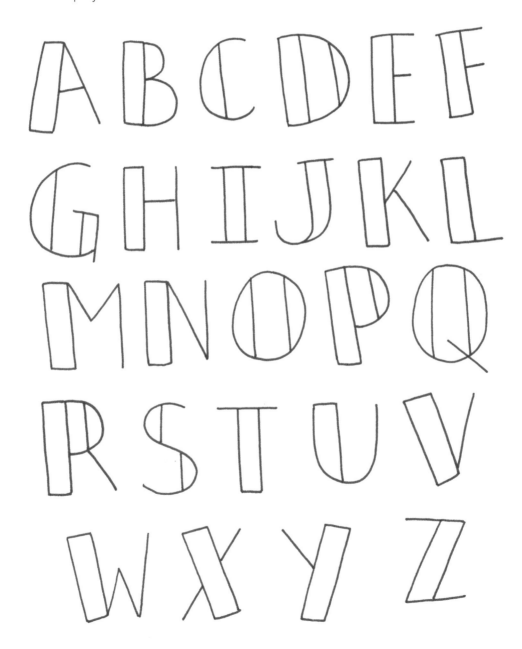

Adding shading and highlights to the pillars in each word help enhance the meaning.

TALL

GRANDE

VENTI

Everyone has a different version of "fancy." My letters combine elements of cursive (page 14) with simple handwriting (page 12). I like to make the downstrokes into pillars (page 26) and add curls for extra fanciness.

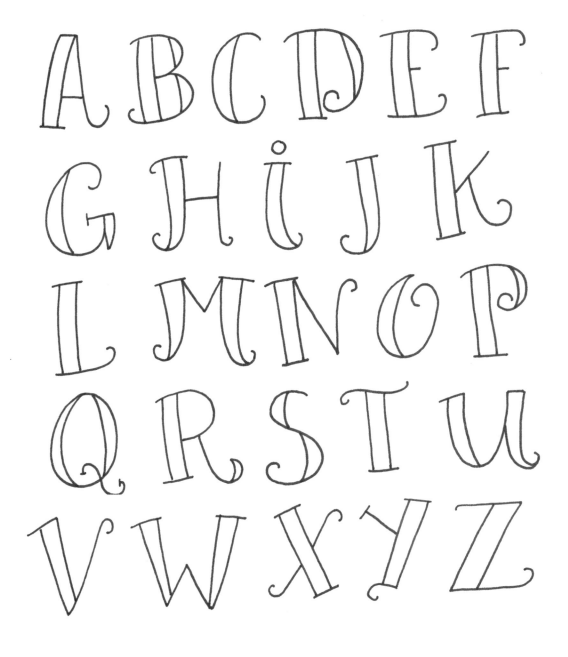

Decorate your fancy letters any way you like. Here, I've decorated each word in a style that matches its meaning.

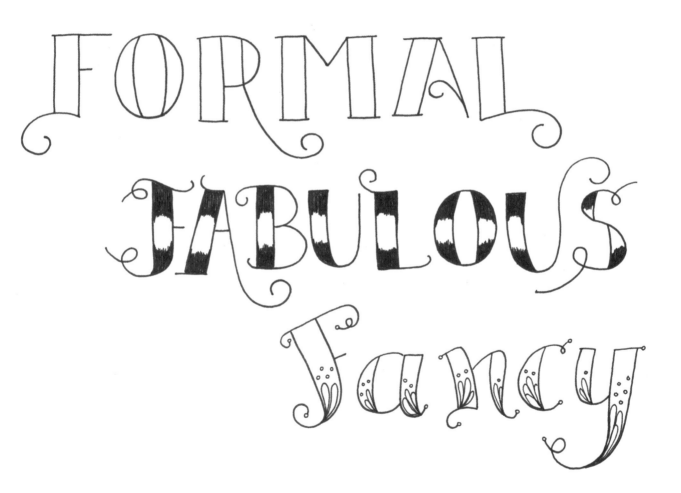

FORMAL

FABULOUS

Fancy

· SERIF LETTERING ·

Serifs, the little strokes that are added to the ends of letters, are a classic style and can be applied to a number of lettering styles in this section, including pillar lettering (page 26), as featured here. Add a touch of fun with a little color.

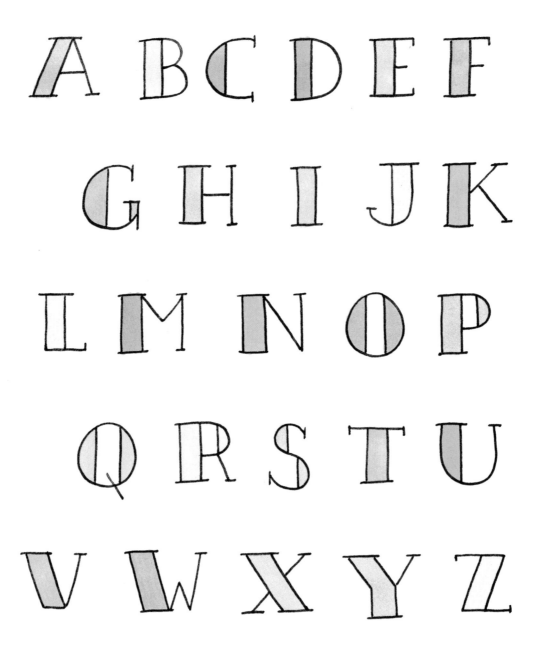

• BROKEN LETTERING •

Look how easy it is to turn simple handwriting (page 12) into something fun and arty. Just draw dashes instead of solid lines!

Just add some dot details to the ends of simple-handwriting letters (page 12) and you have a whole new lettering style.

Aa Bb Cc Dd Ee

Ff Gg Hh Ii Jj Kk

Ll Mm Nn Oo Pp

Qq Rr Ss Tt Uu

Vv Ww Xx Yy Zz

Give the alphabet some extra flair with the curlicue details of this lettering style.

Aa Bb Cc Dd Ee

Ff Gg Hh Ii Jj Kk

Ll Mm Nn Oo Pp

Qq Rr Ss Tt Uu

Vv Ww Xx Yy Zz

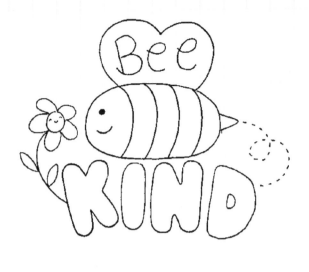

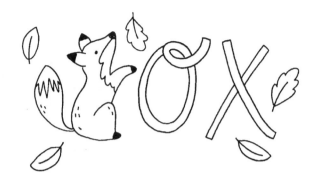

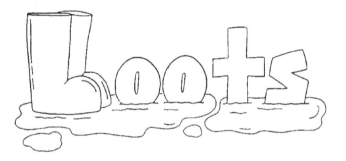

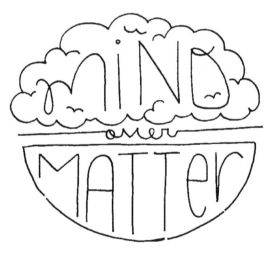

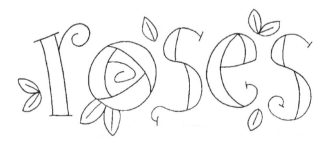

LOLLI

FRIES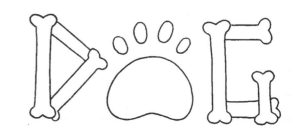

PART II

DOODLE
WORDS

 unicorn

CAT

1. Write the word CAT, but instead of actual letters, use lines and shapes to build each letter. For this design, I imagined things associated with a cat. The letter C turns into a tumbling ball of yarn. The letter A is the cat itself. The letter T is a scratching post.

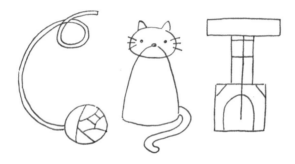

2. Add more detail to each drawing. Using a cat image for the A gives the doodle extra meaning and emphasis.

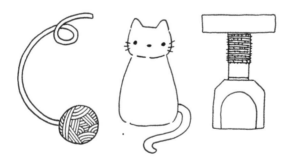

3. Using a fine liner, trace over the lines from step 2 but make sure you don't outline the overlapping sections. You can also add more detail to the drawing, especially in the ball of yarn and scratching post. Erase the pencil lines.

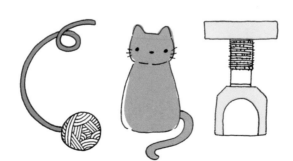

4. Add some purr-fect color to complete your word art.

1. Just as in the CAT doodle (opposite), write the word DOG, using lines and shapes. This time, instead of drawing a dog for the letter O, I decided to draw a paw print. Be sure to leave a little extra space between each letter.

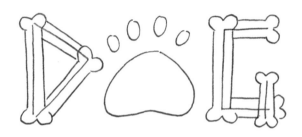

2. Imagine trying to write the letters D and G using bones. Draw several bone shapes overlapping each other to create both of these letters.

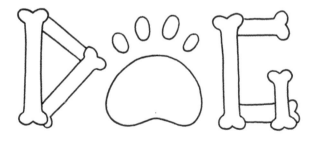

3. Use a fine liner to outline your word art. Erase the pencil lines.

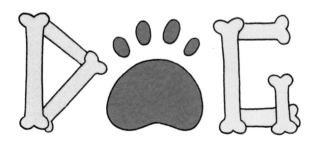

4. Give your word art some fetch-ing color.

1. Write down the letters F, L, M, N, G, and O for the word FLAMINGO in uppercase simple handwriting (page 12). Be sure to add space between the letters, and leave extra room for the letters A and I. Next, make rough drawings of flamingos to represent the letters A and I.

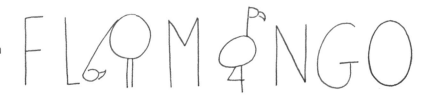

2. Use the pillar lettering style (page 26) to emphasize the letters F, L, M, N, G, and O. Add extra detail to the letters A and I to make them look more like flamingos.

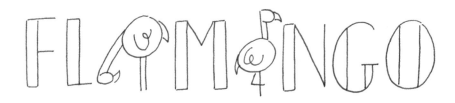

3. With a fine liner, outline your word art. Give more detail to the flamingos by darkening the tips of the beaks and adding eyes. Erase the pencil lines.

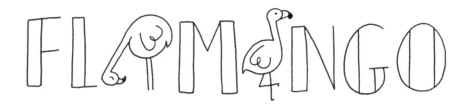

4. Flamingos are pink, so color your flamingos as bright a pink as you can!

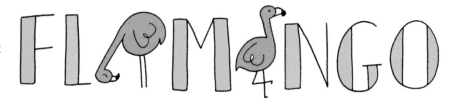

5. Now it's your turn! ..

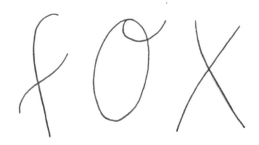

1. Using a combination of simple handwriting (page 12) and cursive (page 14), write the word FOX. I used a lowercase letter F instead of uppercase because it will make the perfect template for drawing a fox.

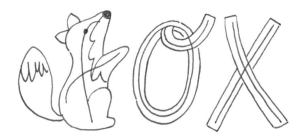

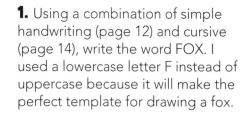

2. Draw a fox around the letter F. Use thin block lettering (page 18) to broaden the letters O and X.

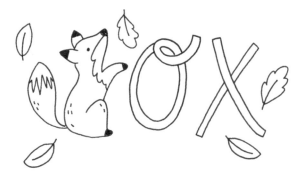

3. Outline your word art with a fine liner, then add more detail by drawing some falling autumn leaves. Erase the pencil lines.

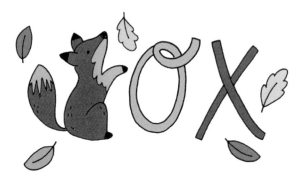

4. When you add color, be sure the fox stands out next to the O and X.

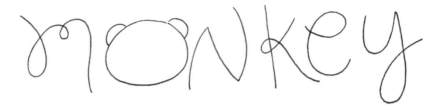

1. Write the word MONKEY in a combination of simple handwriting (page 12) and cursive (page 14). We'll be turning the letter O into a monkey's head, so draw the O as an oval shape instead of a circle and add some ears.

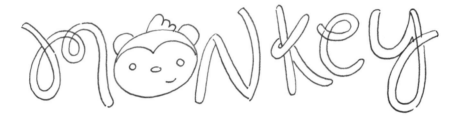

2. Turn all the letters except the O into thin block letters (page 18), and give the monkey a cute face and some fur.

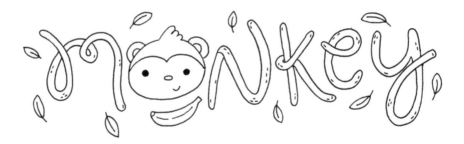

3. With a fine liner, outline your word art and add more detail. Drawing small dots inside the letters gives them more texture and makes them look like they were written with the monkey's tail. Erase the pencil lines.

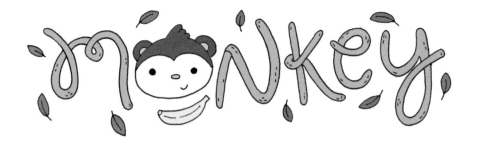

4. Have fun monkeying around with color!

5. Now it's your turn!

1. Make a rough drawing of a whale—with a big head and a tail. Part of the tail will be half of the letter W. Write the remaining letters H, A, L, and E using a combination of simple handwriting (page 12) and cursive (page 14).

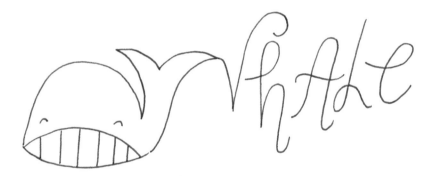

2. Draw the whale's face. The vertical lines you see are not the whale's teeth—nor is it smiling. Fun fact! Some whales, like the blue whale, have throat pleats, or throat grooves, which can expand when they eat.

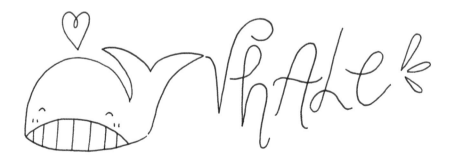

3. With a fine liner, outline your word art and add more detail to your whale—adding hearts and waterdrop shapes will make the drawing extra effective and cute! Erase the pencil lines.

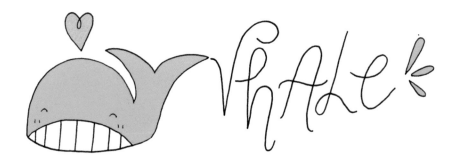

4. Don't forget to color in your cute whale!

5. Now it's your turn!

1. Write the word OCTOPUS in simple handwriting (page 12), with a wide capital O. Be sure to leave a little space between each letter.

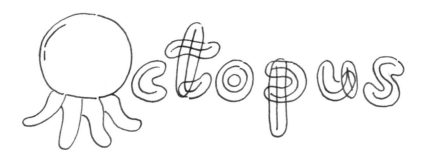

2. Draw arms on the letter O and add a curved line inside the O for texture. Outline the remaining letters, giving them bubble shapes (page 22).

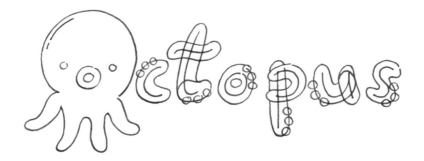

3. Add a cute face to your octopus and 3 small circles (suckers) on each letter. Place the circles anywhere you like. These small circles will make the letters look like they're part of the arms.

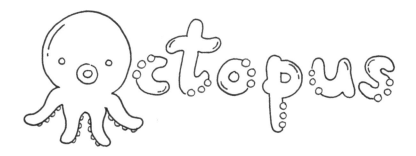

4. Time to outline your word art with a fine liner! Make sure you don't draw over the overlapping marks, and don't forget to erase the pencil lines.

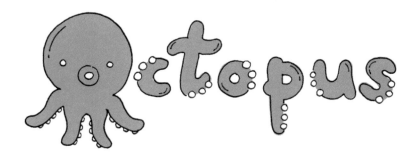

5. Traditionally color your octopus or play with bright colors found in a coral reef.

6. Now it's your turn!

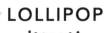

LOLLIPOP

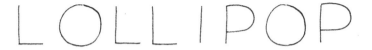

1. Write the word LOLLIPOP in uppercase simple handwriting (page 12). Leave a little space between each letter.

2. Add a second line to the letters L, I, and P, similar to pillar lettering (page 26). Decorate the two Os with swirls and curves to make them look like lollipop heads.

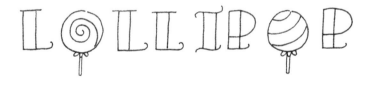

3. Add serifs (page 30) with swirls to the letters L, I, and P. Then give each of the Os a lollipop stick.

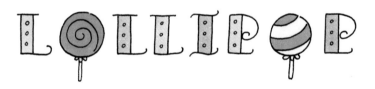

4. With a fine liner, outline your word art. Finish by adding more decorations. Erase the pencil lines. Don't forget to sweetly color your work!

5. Now it's your turn!

ICE CREAM

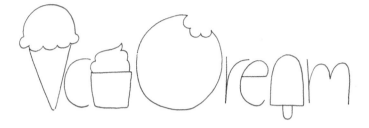

1. For this doodle, spell out the words ICE CREAM using different ice-cream treats to represent some of the letters. A big, round ice-cream sandwich might look like an O, but with a bite out of its side, we'll turn it into the C in Cream.

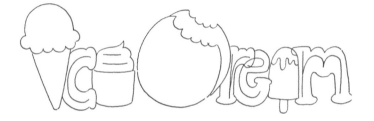

2. Draw around the letters C, R, the second E, and the M, using block serif lettering (page 20). Also add some detail to the ice-cream doodles.

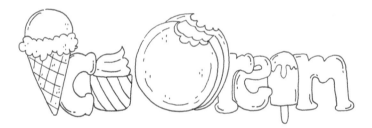

3. The ice-cream doodles help give some realistic detail to the word art, so keep adding detail. With a fine liner, outline your word art. Erase the pencil lines.

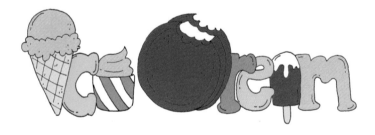

4. Decorate and color the letters in your favorite ice-cream flavors!

5. Now it's your turn!

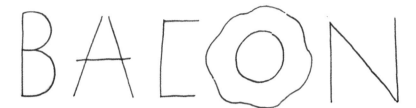

1. For this drawing, imagine writing the word BACON using slices of bacon—except for the letter O, which will be a sunny-side up egg! Write the letters in uppercase simple handwriting (page 12), but make the letters A and N blocky.

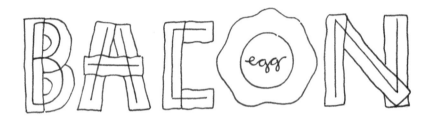

2. Use overlapping lettering (page 24) on the letters B, A, C, and N, so it looks like the bacon slices are lying on top of each other. Make the lines a little wobbly, like the edges of crispy bacon! Oh, and if you want, write the word EGG in lowercase cursive (page 14) in the center of the yolk.

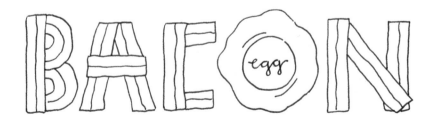

3. Using a fine liner, outline your word art. Add more shaky lines inside each slice to give it the look of bacon. Erase the pencil lines.

BACON egg

4. Just add a few more lines for detail!
And color to make the bacon and egg look extra appetizing!

5. Now it's your turn!

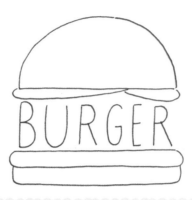

1. Write the word BURGER inside a burger in uppercase simple handwriting (page 12)! Imagine the word sandwiched between two halves of a bun. It's up to you what else you'd like to squeeze in—lettuce, tomato, or cheese?

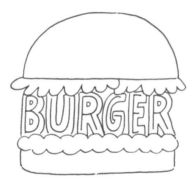

2. I decided to go with just lettuce and the meat. Outline the word BURGER, but don't let the block letters (page 16) get any wider than the bun!

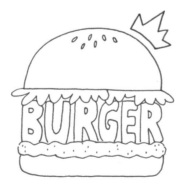

3. With a fine liner, outline your word art. Add some sesame seeds on top of your bun for extra detail. I also added a crown shape! Erase the pencil lines.

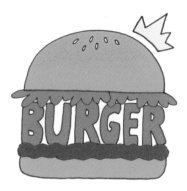

4. There's lots to color in this burger deluxe.

5. Now it's your turn!

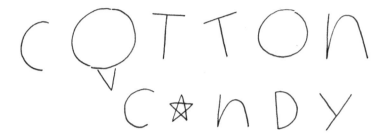

1. Write the word COTTON CANDY using a mix of upper- and lowercase simple handwriting (page 12). Leave some space in between each letter. The two Os will represent the cotton candy itself, so emphasize them more, and I turned the letter A into a star to make it more appealing.

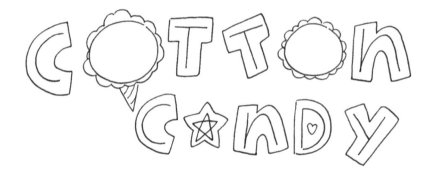

2. Outline the letters C, T, N, D, and Y into block letters (page 16). Turn the two Os into fluffy cloud shapes to create a cotton-candy look!

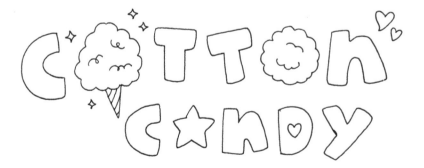

3. With a fine liner, outline your word art. Add some more details and fun shapes: tiny sparkle diamonds and hearts can make your doodles cuter! Erase the pencil lines.

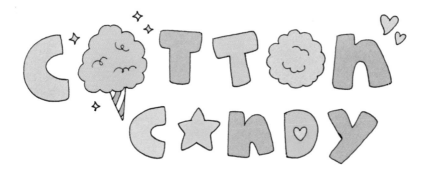

4. Do you like pink or blue cotton candy, or both? Show your color preference here.

5. Now it's your turn!

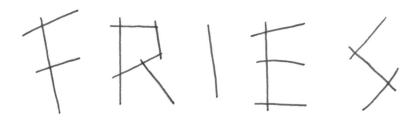

1. Imagine that you're writing the word FRIES using real French fries. Start by drawing the lines in different sizes.

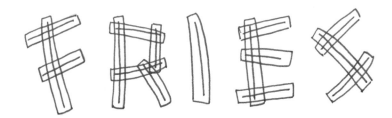

2. Next, using overlapping lettering (page 24), draw around each line to create the look of French fries.

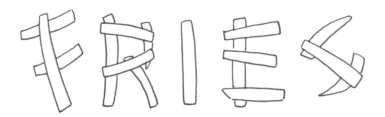

3. With a fine liner, outline your word art. For this, imagine that some pieces are on top of others when you spell out the word. Erase the pencil lines.

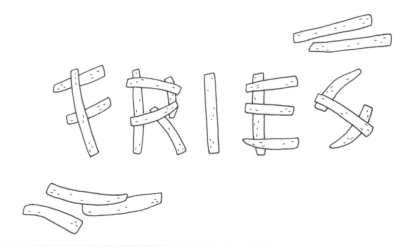

4. Add some short dashes on your fries for a little texture and to create a deep-fried effect.

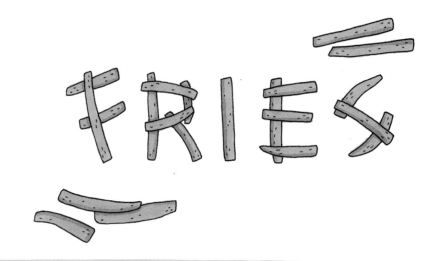

5. Color your fries so they look as good as they taste.

6. Now it's your turn!

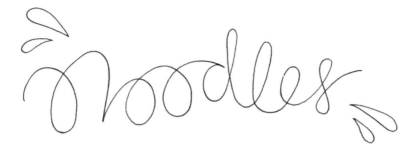

1. Write the word NOODLES in cursive (page 14). Add a few waterdrop shapes on either side to create the idea of noodles in soup.

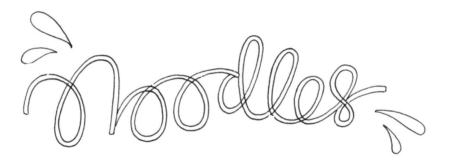

2. Draw around the word, giving the cursive double thickness and turning it into bold letters.

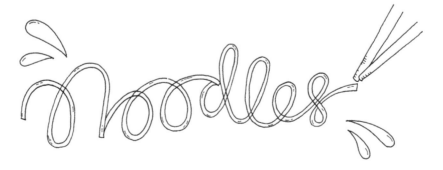

3. With a fine liner, outline your word art. Add more noodle details! I added chopsticks, but you could substitute a fork or spoon or anything you want! Erase the pencil lines.

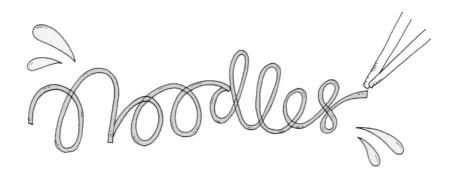

4. Have fun coloring your noodles!

5. Now it's your turn!

1. Write the word PIZZA in uppercase simple handwriting (page 12). Leave some space between each letter.

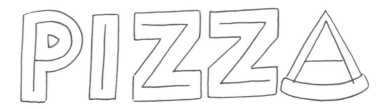

2. Draw around the letters P, I, and Z to turn them into block letters (page 16). Turn the letter A into a pizza slice.

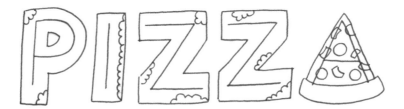

3. Now add bite marks, using scalloped lines along the edges of all the letters—except the letter A. On the A, draw some pizza toppings.

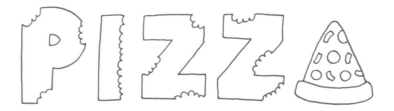

4. With a fine liner, outline your word art, but do not trace the lines that have been "bitten off." Erase the pencil lines.

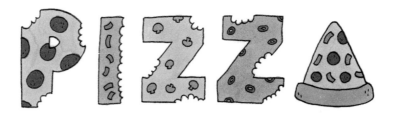

5. Add more pizza toppings and don't forget to color it!

6. Now it's your turn!

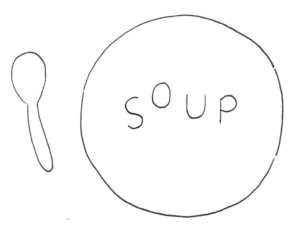

1. Are you familiar with alphabet soup? That's what we're going to draw with this word art. Draw a big circle for the bowl with the word SOUP in uppercase simple handwriting (page 12) floating in the middle of it and a spoon on the side.

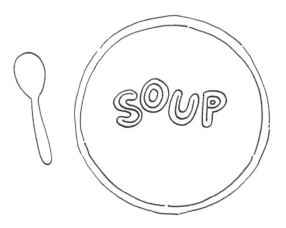

2. Make a smaller circle inside the first to create the rim of the bowl. Then draw around the letters to fatten them up. Round the edges so the letters resemble alphabet noodles, or thin bubble letters (page 22).

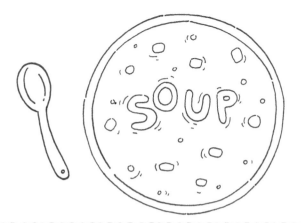

3. What other ingredients do you like in your soup? With a fine liner, draw different shapes to create pieces of potato or carrots, along with outlining your word art and adding short curving lines around everything to give the effect of liquid. Erase the pencil lines.

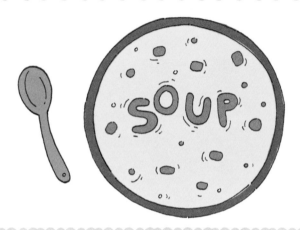

4. Color your soup delicious!

5. Now it's your turn!

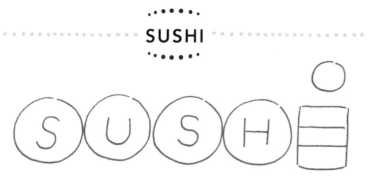

1. Imagine this sushi is served to you lined up on a plate. Draw 4 circles and center the letters S, U, S, and H inside them, in uppercase simple handwriting (page 12). Add a rectangular shape, segmented into 3 sections, for the letter I, and a small circle to dot the I.

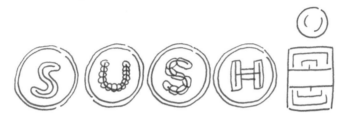

2. Add a second circle inside each of the first circles to look like seaweed wrap. Draw over the letters S, U, S, and H to turn them into sushi fillings. The letter I is *tamago* (Japanese for "egg") with some wasabi dotting it!

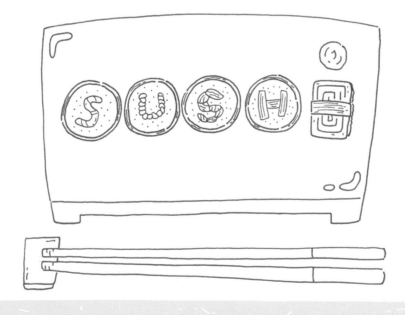

3. For the finishing touches, use the fine liner to outline your word art, draw a rectangle shape for the sushi tray, and add chopsticks. Erase the pencil lines.

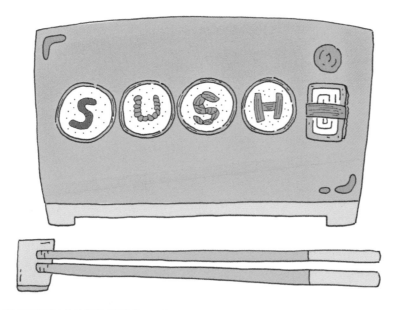

4. Add some vibrant sushi colors.

5. Now it's your turn!

ADVENTURE

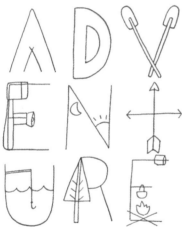

1. The word ADVENTURE has 9 letters, so divide the letters into 3 even lines. Think of things related to nature, camping, and outdoor activities that will work with the shapes of the letters and draw your skeleton with those shapes in mind.

2. Start drawing details for each letter. For example, I turned the letter A into a teepee or a mountain—or both. The letter V is a pair of oars, and so on. Transform each letter by thinking of everything you can that reminds you of nature and maybe trips you've taken and places you've visited. The possibilities are endless!

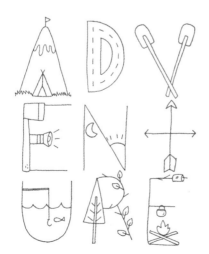

3. With a fine liner, outline your word art and add more details. Erase the pencil lines.

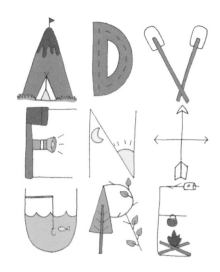

4. Be adventurous with your color choices.

5. Now it's your turn!

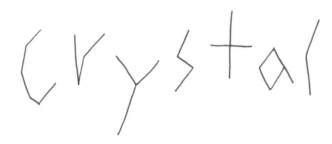

1. Crystals and geodes are very popular right now. For this word art, imagine that the letters are fragments of crystals. Write the word CRYSTAL with handwriting that looks to be bent in places.

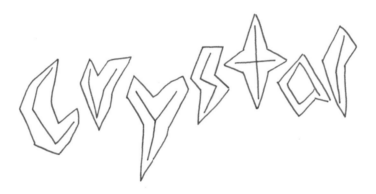

2. Now draw around each letter, making the corners pointy so the letters look like they're made with fragments.

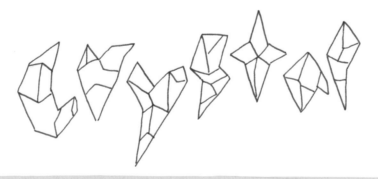

3. With a fine liner, outline your word art. Draw random lines connecting one to another—making the crystals look 3-D. The lines don't have to be perfectly straight. Erase the pencil lines.

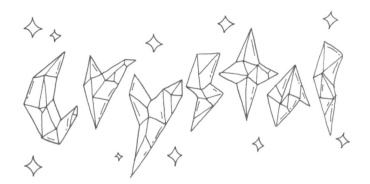

4. Add more details with small lines to look like reflections in glass. Add some sparkle diamonds to give your crystals extra radiance! Erase the pencil lines.

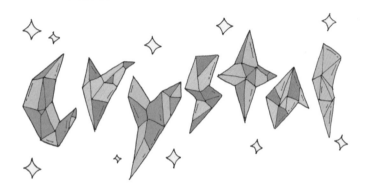

5. Color your word art as shiny as you can.

6. Now it's your turn!

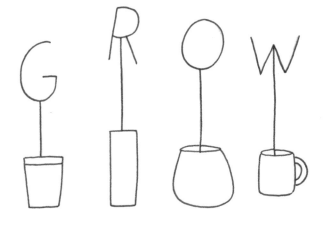

1. For this word art, we'll make the word GROW sprout from pots. Draw 4 different, simple pots—one for each letter, written in uppercase simple handwriting (page 12).

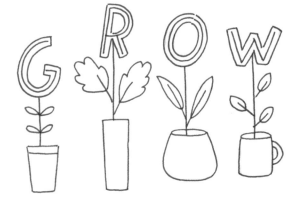

2. Draw around the letters to turn them into thin block letters (page 18). Add leaves to your stems.

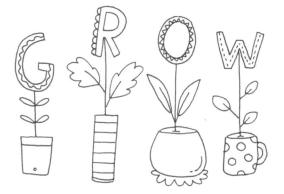

3. With a fine liner, outline your word art. Then decorate your pots and plants! Erase the pencil lines.

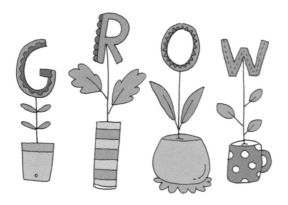

4. Give the pots and flowers bright and happy colors.

5. Now it's your turn!

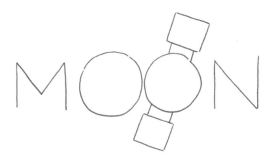

1. Write the word MOON in uppercase simple handwriting (page 12). Leave some space around the letters M and N. Turn the first letter O into a drawing of the moon, and the second letter O into a satellite. Or you can turn it into a spaceship or anything else that you might find in space.

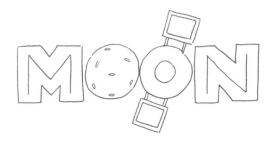

2. Turn the letters M and N into block letters (page 16). With your fine liner, outline your word art. Add more detail to the moon and satellite.

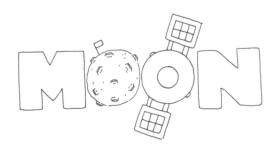

3. Since the focus of this word art is the moon, make sure your moon doodle is more distinguished and detailed than the satellite. Keep the other drawing simple—the moon is the star of this show! Erase the pencil lines.

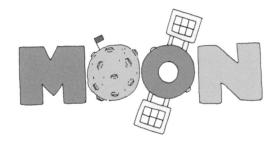

4. Give this word an out-of-this-world feel.

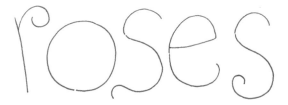

1. Write the word ROSES in lowercase simple handwriting (page 12) with added curlicues. Make the letter O as round and wide as you can.

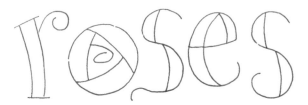

2. Using pillar lettering (page 26), draw a second line for each letter and add serifs (page 30) at the ends of the strokes of the letters R, S, and E. Now focus on the letter O and draw some lines inside to create the look of a rose.

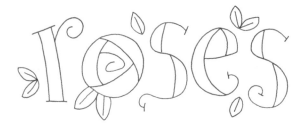

3. With a fine liner, outline your word art and draw a few leaves around the letters for embellishment. Erase the pencil lines.

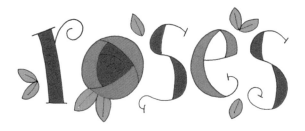

4. Roses come in many colors. What's your favorite?

OCEAN

1. Write the word OCEAN in uppercase simple handwriting (page 12) in a cascading style—one letter up and the next letter down, as if they are bobbing in water. The letter O is a life preserver.

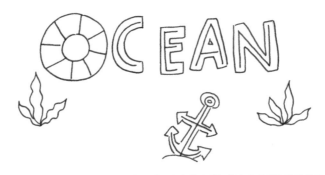

2. Imagine the bottom of the ocean and draw things that you might find there, like seaweed, anchors, or even a treasure chest. Turn the letters C, E, A, and N into thin block letters (page 18).

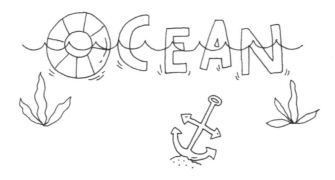

3. With a fine liner, outline your word art and draw a scalloped line or two of waves. Add small, curvy lines on the sides of each letter to make it look as if the letters are floating in the water. Erase the pencil lines.

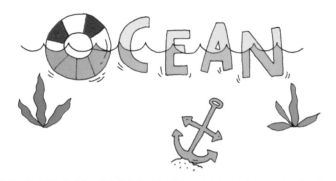

4. Try a nautical color theme for your word art.

5. Now it's your turn!

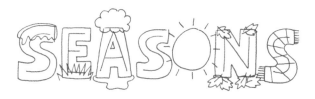

1. In this word art, we'll turn the word SEASONS into all four seasons. First, write the word SEASONS in uppercase simple handwriting (page 12), leaving some space around each letter for more detail. The letter O represents the sun for summer.

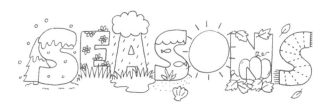

2. It's important to start with pencil for this word art because you'll want to work out lots of important little details. Draw each letter with block letters (page 16), then draw things that remind you of the different seasons. For instance, I drew snow on top of the first letter S for winter and a scarf on the last letter S for fall.

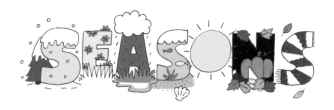

3. With a fine liner, outline your word art and draw more seasonal elements, like rain, flowers, the sea, falling leaves, and even a pumpkin, to represent the seasons. Erase the pencil lines.

4. Add seasonal colors!

5. Now it's your turn!

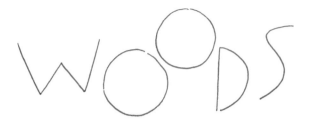

1. Just as we did for the OCEAN doodle art (page 22), write the word WOODS in uppercase simple handwriting (page 12) in a cascading—up-and-down—style.

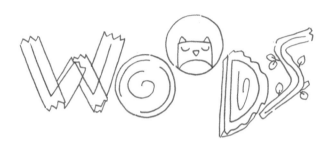

2. Imagine you're using pieces of wood to make the letters. To make the word even more interesting, turn one letter O into a home for a sleeping owl.

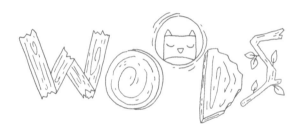

3. With a fine liner, outline your word art and give your letters the look of wood grain and bark by drawing lines of different sizes. Also add some swirls, crooked lines, and leaves for an extra-woody effect! Erase the pencil lines.

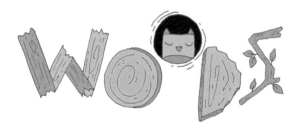

4. Color in your word art in a rustic palette.

5. Now it's your turn!

FISH AND CHIPS

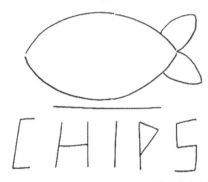

1. Draw a simple fish shape with a line underneath it. Write the word CHIPS below the line. The letters should be uppercase and angular with corners. Leave a little space between them.

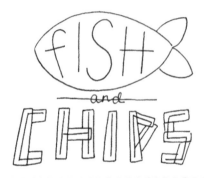

2. Write the word FISH inside the fish drawing, filling the space. Draw over the word CHIPS using overlapping lettering (page 24) to make the letters look like French fries. Write the word AND in lowercase cursive (page 14), centered in the line between FISH and CHIPS.

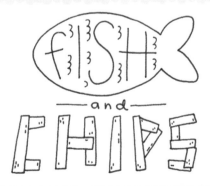

3. With a fine liner, outline your word art. Add some scales to the fish and some small crispy details to the CHIPS. Erase the pencil lines.

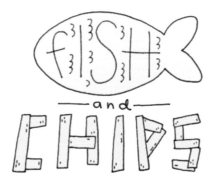

4. Don't forget to add color!

5. Now it's your turn!

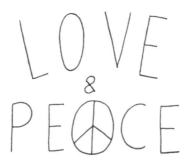

1. Write the words LOVE and PEACE in uppercase simple handwriting (page 12), leaving some space between the letters. Make sure to arch the position of the letters in LOVE. Substitute the letter A in PEACE with a drawing of a peace symbol. Center an ampersand between the words.

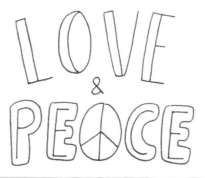

2. Using pillar lettering (page 26), draw a second line for each letter in LOVE. Draw around the letters in the word PEACE using bubble lettering (page 22).

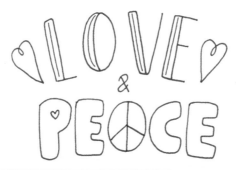

3. With a fine liner, outline your word art. Add lines within the letters of LOVE and draw some doodle hearts for added decoration. Erase the pencil lines.

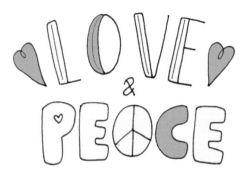

4. Use serene colors for your word art.

5. Now it's your turn!

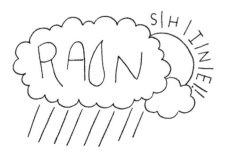

1. Begin by drawing some rain clouds with the sun peeking around them. Write the word RAIN inside the cloud, using a raindrop for the letter I. Write the word SHINE in between the rays of the sun. Draw slanting lines under the cloud to represent rain.

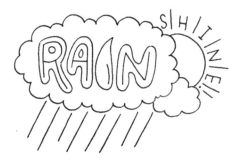

2. Draw around the letters in RAIN, giving the letters bubble shapes (page 22).

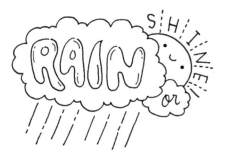

3. Add more detail by adding curved lines inside the letters of RAIN, so they look like they're made from drops of water. Add a cute smiley face to the sun! When you trace over your word art with a fine liner, break the diagonal lines under the cloud and coming out of the sun into dashes. Don't forget to write OR in lowercase cursive (page 14) in the small cloud. Erase the pencil lines.

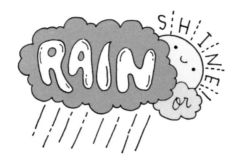

4. Use a combination of dark and light colors for your word art.

5. Now it's your turn!

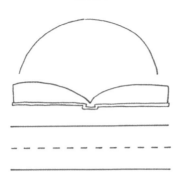

1. Begin by drawing an open book with an arc above it, along with handwriting practice lines below it, to symbolize reading and writing.

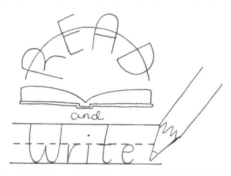

2. Write the word READ in uppercase simple handwriting (page 12) along the arc, and the word WRITE, with a capital W, inside the practice lines. End the word WRITE with a drawing of a pencil, as though it was just written down. Write AND in lowercase cursive (page 14), centered between the book and the practice lines.

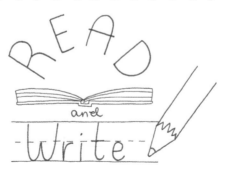

3. With a fine liner, outline your word art. Draw more lines in the book to indicate pages. Erase the pencil lines.

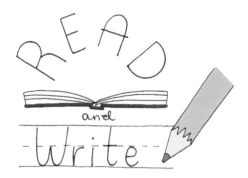

READ
and
Write

4. Don't forget to color in your word art!

5. Now it's your turn!

SALT O

PEPP[]R

1. Write the words SALT and PEPPER in uppercase simple handwriting (page 12), making the letters a little crooked and leaving some space in between the letters. Use a salt-shaker shape for the letter A in SALT. Use a little rectangular pepper packet to replace the second E in PEPPER. To the right of SALT, draw a vertical oval shape.

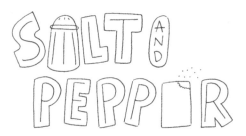

2. Draw around the letters to make them block letters (page 16). Add some detail to the salt shaker and the pepper packet. Vertically write the word AND in uppercase simple handwriting inside the oval shape.

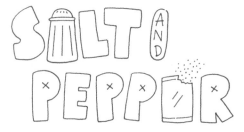

3. With a fine liner, outline your word art. I added a small X in the Ps and R of PEPPER for more detail. Erase the pencil lines.

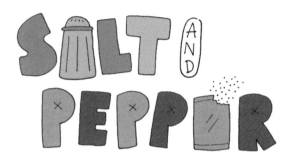

4. Don't forget to color in your word art!

5. Now it's your turn!

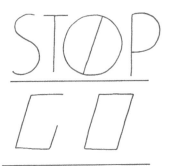

1. Write the word STOP in uppercase simple handwriting (page 12). I used a "No" or "Don't" symbol for the letter O, but you could use an octagonal stop-sign shape instead. When writing the word GO, make the uppercase letters box-shaped and slanted to signify action. Leave some space between the G and the O. Draw guidelines above and below GO.

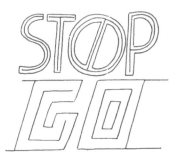

2. Draw thin block letters (page 18) around the word STOP. Be sure your block-letter outlines (page 16) are thick and slanted when you draw around the G and O in GO.

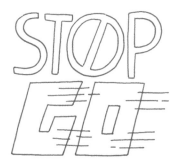

3. With a fine liner, outline your word art. Adding horizontal lines to the word GO will give it "speed." Erase the pencil lines.

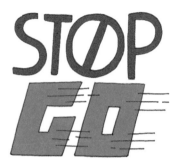

4. Use bright colors for your word art, like those found on street signs or race cars.

5. Now it's your turn!

$S U Q A R$

1. For the word SUGAR, use things related to candy that will work with the shapes of the letters. Draw a small banner underneath SUGAR—that's where AND will go. The plan is to keep the word SPICE simple but to add some doodles of different spices around it. So draw parallel lines to map out where that word will sit underneath SUGAR.

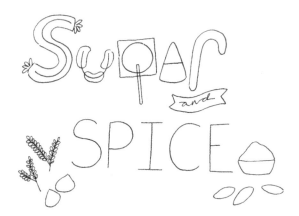

2. Use your imagination to turn each letter of SUGAR into a sweet. For example, I made the G a lollipop shape, the A a candy corn, and the R a candy cane. Write the word SPICE in uppercase simple lettering (page 12). Draw some doodles of spices around it, like a bowl of seasoning, some leaves, seeds, etc. Write the word AND in lowercase cursive (page 14) in the banner.

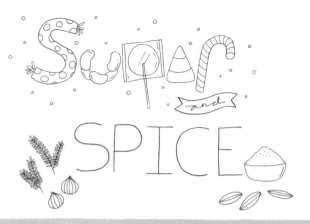

3. With a fine liner, outline your word art. Now for the fun part! Add details and decorations to your doodle word art. Erase the pencil lines.

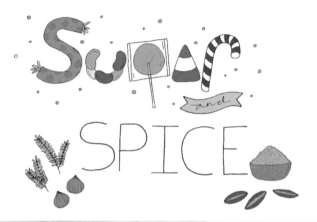

4. Use bright colors for SUGAR and earthy colors for SPICE.

5. Now it's your turn!

BEE KIND

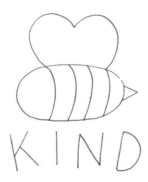

1. Here we'll use a play on words, substituting BEE for BE. Draw a bee using simple shapes with heart-shaped wings. Write the word KIND, slightly crooked and in uppercase simple handwriting (page 12), below it.

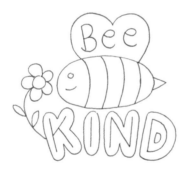

2. Write the word BEE, with a capital B, inside the wings of the bee doodle. Draw around the word KIND using bubble lettering (page 22). Add a cute face and a flower.

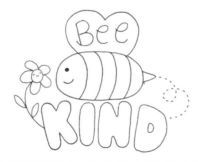

3. With a fine liner, outline your word art, fill in the eye, and add a swirly line in dashes to make it look like the bee is flying. Erase the pencil lines.

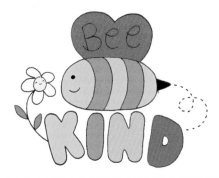

4. Add happy colors to make it pop!

5. Now it's your turn!

C R E A T E

1. For this word, we'll use things related to arts-and-crafts tools that work with the shapes of the letters.

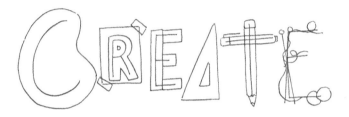

2. Use your imagination to turn each letter of CREATE into a tool. For example, I am making the C a paint palette, the A a triangle, the T a crossed pen and pencil, and the second E knitting needles and yarn.

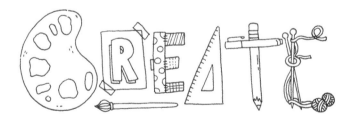

3. With a fine liner, outline your word art. Now for the fun part! Add as much detail as you like, making sure that each doodle still resembles the letter it's meant to be. Erase the pencil lines.

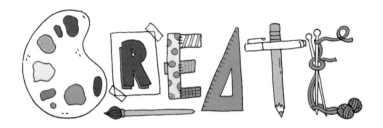

4. Be creative with your color palette.

5. Now it's your turn!

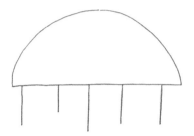

1. For this word art, I had a baby mobile in mind. Baby mobiles are placed near a crib to help a baby fall asleep. What could better suggest the idea of dreaming? Start by drawing a half sphere with five strings of varying lengths hanging from it.

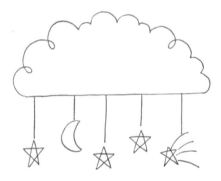

2. Turn the arc of the half sphere into a fluffy cloud shape for the top of the mobile, then hang stars and moons from the 5 strings. Erase the arc pencil line.

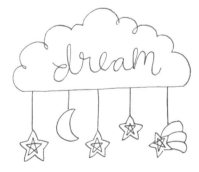

3. Using lowercase cursive (page 14), write the word DREAM in the cloud, and then outline the stars to make them larger and bubbly, along with the shooting star.

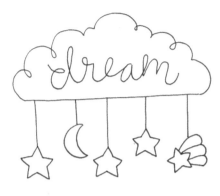

4. With a fine liner, outline your word art. Erase the pencil lines.

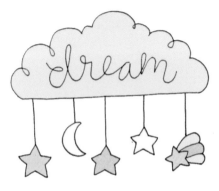

5. Add soothing colors to make this doodle art dreamier!

6. Now it's your turn!

1. For this word art, we'll turn the word EMBRACE into an actual embrace by making the letter E at each end of the word reach out for a hug. I planned to draw the word using block lettering (page 16), so I started by setting up a template—a long, narrow rectangle with lines extending up.

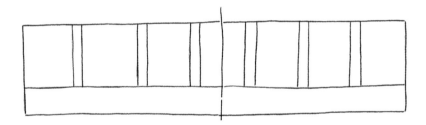

2. EMBRACE has 7 letters, so you'll need 7 rectangles to hold them, with spaces in between. I added a line down the middle, through the center rectangle, to divide it.

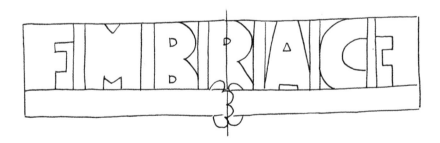

3. Draw a letter in each rectangle. Draw the final E facing inward. Give both Es arms that reach for each other.

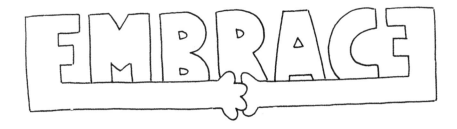

4. With a fine liner, outline your word art. Erase the pencil lines.

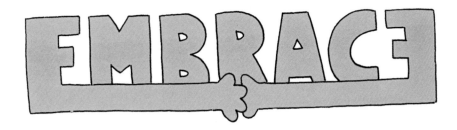

5. Don't forget to color your word art!

6. Now it's your turn!

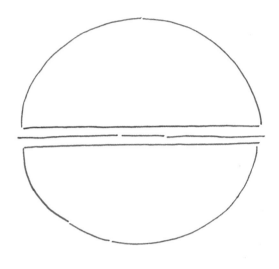

1. Imagine a circle cut in half, creating two half-sphere shapes, one above the other. Draw this as your template, with a horizontal line, broken in the center, drawn between the half spheres.

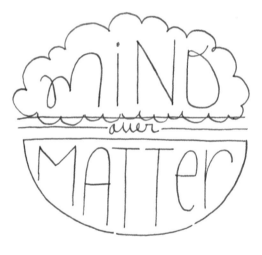

2. Turn the top half sphere into a cloud shape to represent the mind and write the word MIND in a mix of styles, filling the space. Erase the arc pencil line. Write the word MATTER in a combination of upper- and lowercase simple handwriting (page 12) in the bottom half sphere, filling the space. Write the word OVER in lowercase cursive (page 14) in the center of the horizontal line between the half spheres.

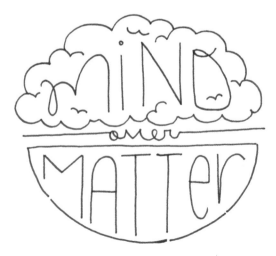

3. With a fine liner, outline your word art and add a little more fluff to the cloud shape by drawing short scalloped lines inside it. Erase the pencil lines.

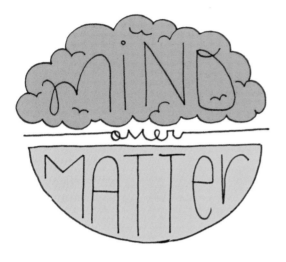

4. Try using bold colors for this mantra.

5. Now it's your turn!

R ⨆ L A X

1. I wanted to keep this word art as simple as possible because of the meaning behind it. Write the word RELAX in uppercase simple handwriting (page 12), but draw the letter E lying down as if it's sleeping. Draw a line below the word, leaving enough space as a guide for block lettering (page 16) in the next step.

2. Draw around the letters to turn them into block letters.

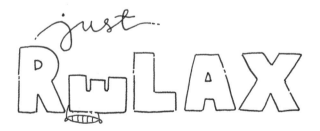

3. With a fine liner, outline your word art, add the word JUST in lowercase cursive (page 14) above RELAX, and tuck in a pillow under the letter E! Erase the pencil lines.

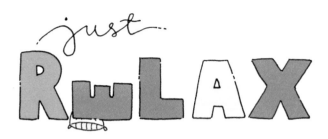

4. Give this word art a calming color palette.

5. Now it's your turn!

1. Set up a template with guidelines to help write the words in the next step. Add a smile underneath them.

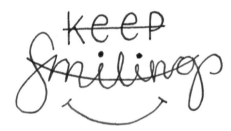

2. Over the lines, write the words KEEP in simple handwriting (page 12) and SMILING in cursive (page 14). Make sure the word SMILING follows the curve of its line (to become a smile itself). Darken the dot over each letter I to make them look like eyes.

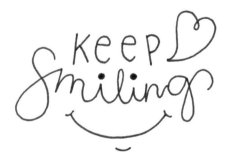

3. With a fine liner, outline your word art. Add a heart and also a curve below the smile to make a cute chin dimple. Erase the pencil lines.

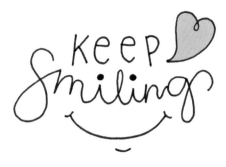

4. Use happy colors for this word art!

5. Now it's your turn!

1. Start by drawing a template with a straight line above a banner shape.

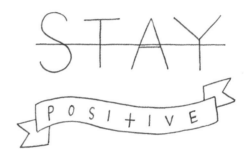

2. Write the word STAY in uppercase simple handwriting (page 12) along the line. In the banner, write the word POSITIVE, also in uppercase simple lettering, but turn the letter T into a plus sign (+) to emphasize the meaning of the word.

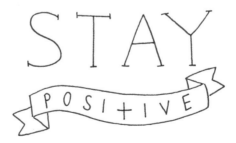

3. Add serifs (page 30) to the word STAY and then outline your word art with a fine liner. Erase the pencil lines.

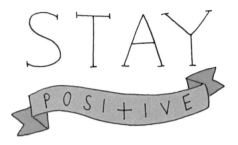

STAY POSITIVE

4. Try coloring the banner in a bright color.

5. Now it's your turn!

· · · · · ·
· CASTLE ·
· · · · · ·

CASTLE

1. Write the word CASTLE in uppercase simple handwriting (page 12), with space between the letters. Make the A a triangle. Add serifs (page 30) to the ends of the letters C, S, and L. The letters A, T, and E will be turned into castle structures for this word art.

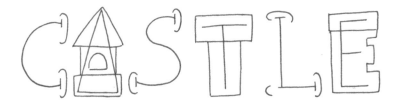

2. Draw curved lines around the serifs. Then draw around the letters A, T, and E to start creating the castle structures!

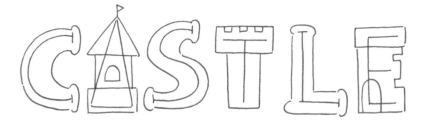

3. Draw around the C, S, and L to turn them into block serif letters (page 20). Add more castle-like features to the other letters.

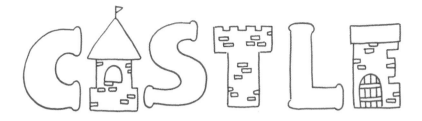

4. With a fine liner, outline your word art and draw tiny rectangles to create the brick walls, windows, and doors of the castle structures. Erase the pencil lines.

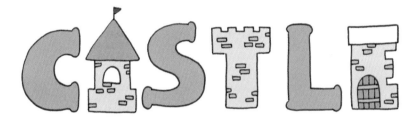

5. Finish off with some stone-like color.

6. Now it's your turn!

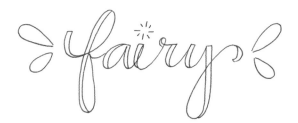

1. Write the word FAIRY in lowercase cursive (page 14). Don't dot the letter I.

2. If you know how to do calligraphy, you don't need to follow this step. But if you are like me and you struggle making brushstrokes, then we'll proceed using faux calligraphy. Draw a second line on each of the downstrokes of the letters. Add a sparkler to dot the I and add little fairy wings on each side of the word.

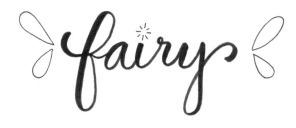

3. With a fine liner, outline your word art, making the downstrokes darker, if you like. Try creating this design in a pen color other than black for a very different look.

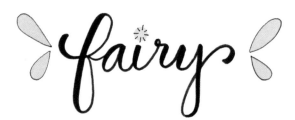

4. Add ethereal colors to your word art.

5. Now it's your turn!

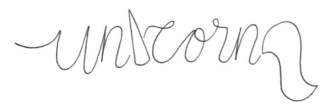

1. Write the word UNICORN in lowercase cursive (page 14), substituting a unicorn's horn for the letter I and adding a thick tail to the end of the word.

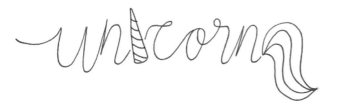

2. Add lines to the horn and tail to give them more detail.

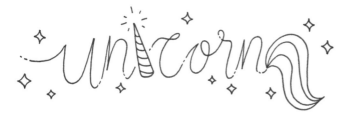

3. With a fine liner, outline your word art. To make your doodle word even more magical, add some sparkle diamonds, along with shimmer lines off the horn! Erase the pencil lines.

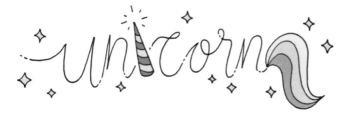

4. Choose magical colors for your word art.

5. Now it's your turn!

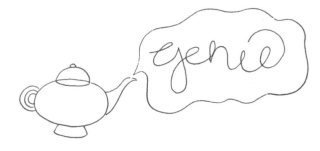

1. The word GENIE is associated with a magic lamp, so for this word art, we'll draw the word GENIE coming out of a lamp. Draw a rough draft of a lamp using simple shapes, then write the word GENIE in lowercase cursive (page 14) inside a word bubble.

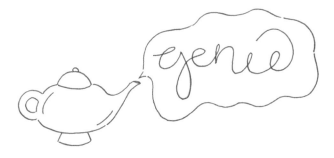

2. With a fine liner, outline the lamp and add more details. Also outline your word art. Erase the pencil lines.

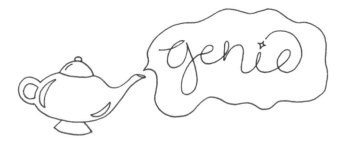

3. Finish by adding highlights to your lamp to make it look like it's polished. Dot the I in GENIE with a sparkle diamond.

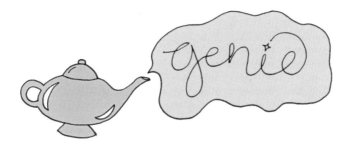

4. Color in the magic lamp nice and shiny.

5. Now it's your turn!

MERMAID

1. Write the word MERMAID in slanting uppercase simple handwriting (page 12). Make sure the tail of the R is long and curved and the body of the I has been drawn using pillar lettering (page 26).

MERMAID

2. Turn the other letters into pillar letters, like you did with the I.

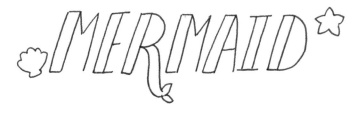

3. Add a finlike shape to the tail of the letter R for a mermaid's tail. Add shells and starfish for more decoration.

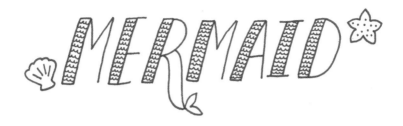

4. With a fine liner, outline your word art. Add detail to each letter by drawing fish scales in a scalloped pattern. Other things you might want to add include water splashes, swimming fish, and other kinds of seashells. Erase the pencil outlines.

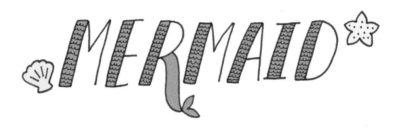

5. Fill in the word art with fun tropical colors.

6. Now it's your turn!

M O N S T E R

1. Write the word MONSTER, in all uppercase letters in simple handwriting (page 12), leaving space between the letters and making the letter S blocky. The letter O is going to end up as an eyeball, so get that started in this step.

MONSTER

2. Draw around the letters to give them a heavier form. For this word art, we'll imagine that the letters themselves are monsters or parts of creepy-crawlies, hence adding some toes to the letter T.

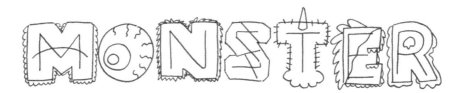

3. In this step, keep your pencil marks light because you might have to try out several rough drafts before inking your design and erasing the pencil. Think of things that you associate with monsters—this could include scales, fur, hair, slime, horns, and pointy teeth!

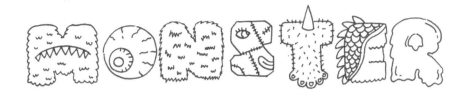

4. With a fine liner, outline your word art. Add even more monstrous details to your drawing! Erase the pencil lines.

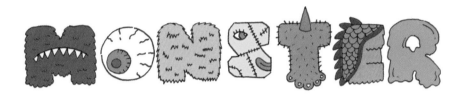

5. Make sure the colors you choose are scary as well!

6. Now it's your turn!

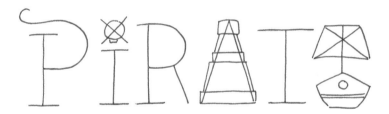

1. This doodle is similar to the CASTLE doodle word (page 106). We'll alternate the letters with things that remind us of pirates and pirate ships. Start by writing the word PIRATE, leaving some space between each letter. The P should have an exaggerated tail, and the letters I, A and E will become things associated with pirates. Dot the letter I with a rough outline of a skull and crossbones.

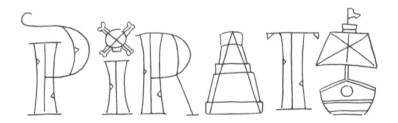

2. Add serifs (page 30) to the P, R, and T and give more detail to the letters I, A, and E. The letter A will become a spyglass, and the letter E will turn into a pirate ship! You can substitute ideas of your own!

3. Use pillar lettering (page 26), adding strokes to make the letters thicker. Add small triangles along the edges of the letters, making them look ragged and torn. Give more detail to the skull and crossbones over the letter I and the pirate ship of the letter E.

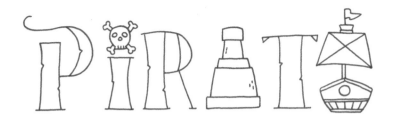

4. With a fine liner, outline your word art and add any final details. Erase the pencil lines.

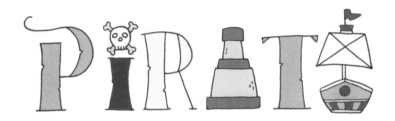

5. Try a fierce color palette here.

6. Now it's your turn!

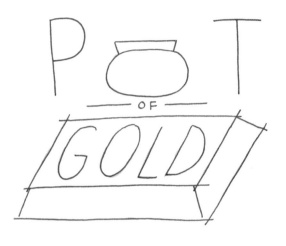

1. Write the word POT in uppercase simple handwriting (page 12), substituting a cauldron or pot for the letter O. Below the word POT, draw a gold bar and write the word GOLD in slanted, uppercase simple handwriting inside it. Center the word OF in uppercase simple handwriting, with lines around each side, between POT and GOLD.

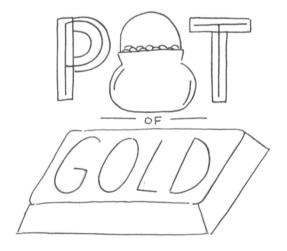

2. Draw around the letters P and T to make them block letters (page 16). Add a handle and scallop shapes for gold coins to the pot. Also add curved lines to the pot to give it texture.

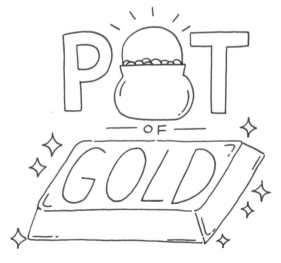

3. With a fine liner, outline your word art. Make that gold bar shimmer by adding sparkle diamonds and texture lines! Also add shimmer lines off the pot. Erase the pencil lines.

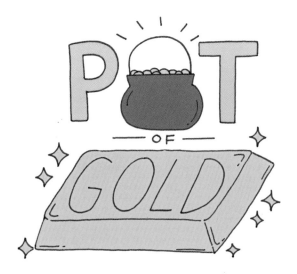

4. Don't forget to make that gold shine!

5. Now it's your turn!

1. Write the word WITCHES in cursive (page 14). Below it, center an ampersand and then write the word WIZARDS in uppercase simple handwriting (page 12), as if the letters are floating in the air. Substitute the letter I in WIZARD with a thunderbolt shape and curve the tails of the Z.

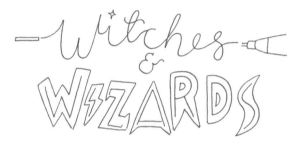

2. Surround the word WITCHES with the ends of a broom. Outline the word WIZARD with block letters (page 16), but making the points of the letters extra pointy.

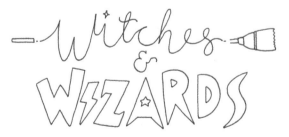

3. With a fine liner, outline your word art. To help make your word art magical, dot the letter I in WITCHES with a sparkle diamond and make the opening in the letter A in WIZARDS a star! Erase the pencil lines.

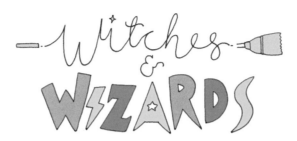

Witches & Wizards

4. Add some sorcery with color.

5. Now it's your turn!

······
BOARD GAMES
·····

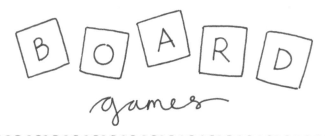

1. For this word art, imagine board-game pieces. Draw 5 Scrabble tiles to hold uppercase simple handwriting (page 12), for the word BOARD. Write the word GAMES in lowercase cursive (page XX) underneath.

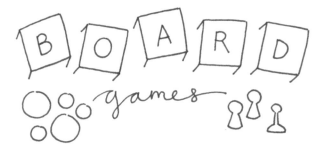

2. Add lines to the Scrabble tiles to start making them look 3-D. Draw other tokens or board game pieces, like a die, checkers, or chess pieces.

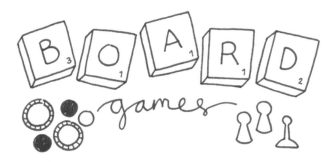

3. Complete the 3-D shapes of the Scrabble tiles. With a fine liner, outline your word art. Add a number, or point amount, to each tile and any details to the other game pieces. Erase the pencil lines.

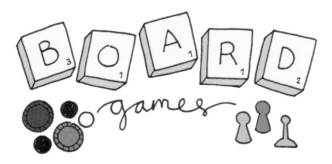

4. Don't puzzle too much over color!

5. Now it's your turn!

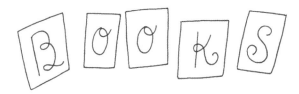

1. Create 5 rectangles, in slightly different sizes and positions—these will represent books. Now write the word BOOKS in uppercase letters in a combination of simple handwriting (page 12) and cursive (page 14), one letter in each rectangle.

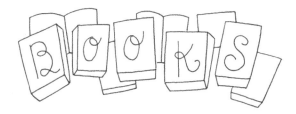

2. Turn the rectangles into 3-D shapes, and then add more rectangular books behind the first row. You can even draw some of them as open books!

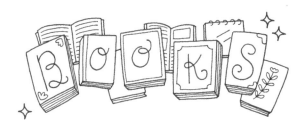

3. With a fine liner, outline your word art. Time to add details! Books have words on pages, so add a stack of horizontal lines to the open pages to create this look. Decorate the covers or even draw illustrations inside the books. And why not add some sparkle diamonds?! Erase the pencil lines.

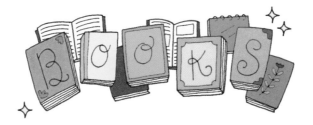

4. Turn your library into a rainbow of books.

5. Now it's your turn!

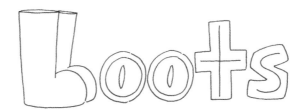

1. Write the word BOOTS in lowercase letters, except substitute the letter B with a boot shape.

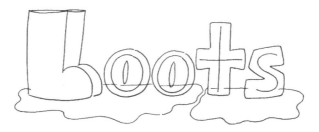

2. Add another boot behind the first one of the letter B to make a pair. Draw around the other letters to create block letters (page 16).

3. Since we use boots when it rains and snows, I drew puddles under the word.

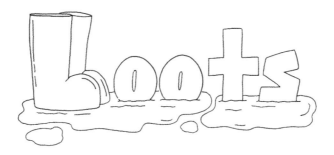

4. With a fine liner, outline your word art. Time to add details! Add lines to the boots to give them texture and wavy lines to the puddles and the bottoms of the letters to emphasize that they are sitting in the puddles. Erase the pencil lines.

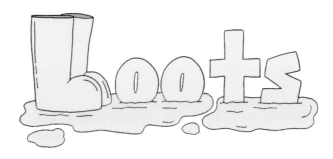

5. Add bright colors to a dreary day.

6. Now it's your turn!

BUTTONS

1. Write the word BUTTONS in uppercase simple handwriting (page 12), leaving space between the letters and making the letter S blocky.

BUTTONS

2. Draw around all the letters—except the letter O—using overlapping lettering (page 24). Draw 4 small circles inside the letter O to turn it into a big button.

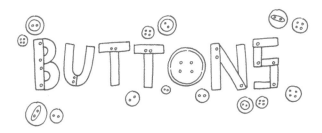

3. With a fine liner, outline your word art. On the overlapping letters, add small circles along the seams to make it look as though they were buttoned together. Draw buttons of varying shapes, styles, and sizes around the letters. Erase the pencil lines.

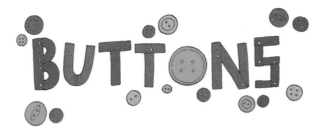

4. Have fun coloring this word art!

5. Now it's your turn!

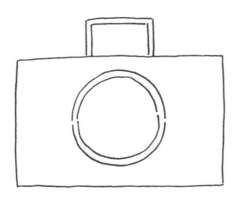

1. Draw a camera using simple shapes. Don't forget the flash and lens!

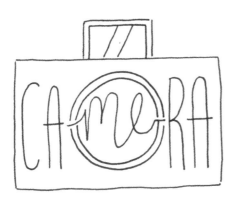

2. Write the word CAMERA inside the rectangle, using tall uppercase letters for the letters C, R, and A. Write the M and E, in lowercase cursive (page 14) inside the camera's circular lens.

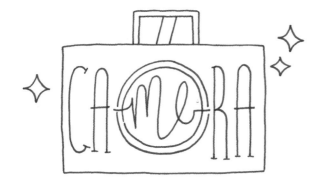

3. With a fine liner, outline your word art. Add diagonal lines to the flash and sparkle diamonds around the camera to add some shine. Erase the pencil lines.

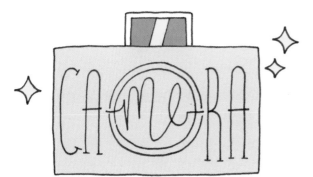

4. Don't forget to add color!

5. Now it's your turn!

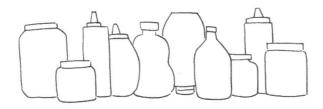

1. For this word art, we'll start with a row of 10 condiment containers because the word CONDIMENTS has 10 letters. Draw different sizes and shapes of condiment jars, tubs, and bottles.

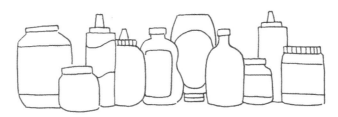

2. Add label and lid details to each container, making sure the letters of the word will fit on the labels.

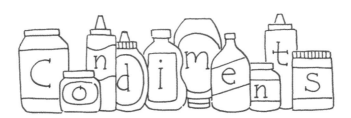

3. Write a letter on each label all in lowercase simple handwriting (page 12) with serifs (page 30). With a fine liner, outline your word art. Erase the pencil lines.

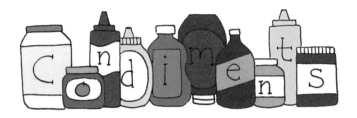

4. Add color, of course!

5. Now it's your turn!

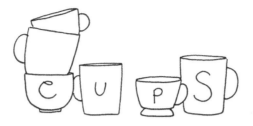

1. Just as we did for the doodle word CONDIMENTS (page 132), draw a cluster of cups in different styles and place 1 letter on each cup. To make this word art more interesting, I stacked a few cups on top of each other and varied the letter style.

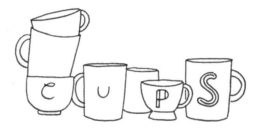

2. Outline the handles of the cups and use a different style of lettering on each cup. Also add another cup or two to the background to fill any open space.

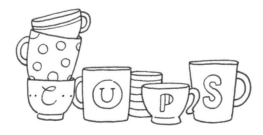

3. With a fine liner, outline your word art. Add lots of fun details! Erase the pencil lines.

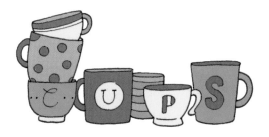

4. Give your cups a fun palette.

5. Now it's your turn!

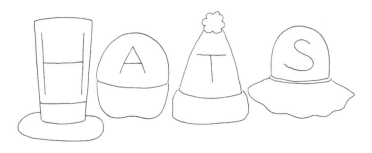

1. Draw 4 different kinds of hats and write the word HATS, 1 letter on each hat. The letters can be different sizes.

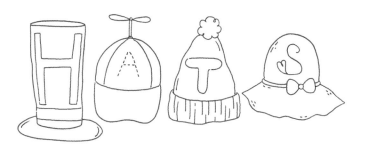

2. Use a different lettering style for each letter and add more details to the hats.

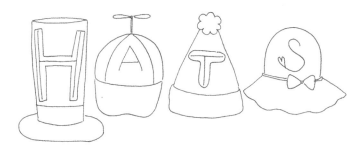

3. With a fine liner, outline your word art. Add any additional details to the hats. Erase the pencil lines.

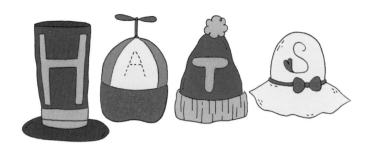

4. Give your hats some playful color.

5. Now it's your turn!

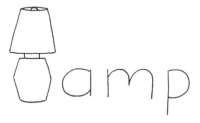

1. As we did for the BOOTS doodle word (page 126), write the word LAMP in lowercase letters, except substitute the letter L with a lamp shape.

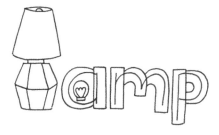

2. Add some stylish details to the lamp. For the other letters, draw around the letters using overlapping lettering (page 24) and add a light bulb inside the letter A.

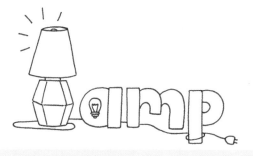

3. With a fine liner, outline your word art. To make your word art more interesting, draw the lamp's cord around the letters and add some glow lines to the lamp! Erase the pencil lines.

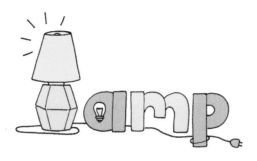

4. Light up your word art with some color.

5. Now it's your turn!

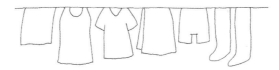

1. Start by drawing a laundry line, then hang 7 items of clothing up to dry for the 7 letters in LAUNDRY.

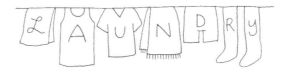

2. Write the word LAUNDRY, 1 letter on each item of clothing. Vary the letters, if you want, to give each item of clothing a different design.

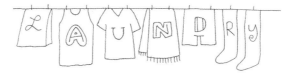

3. Add details to the laundry, including lines for the clothespins and different lettering styles.

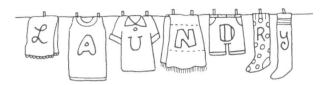

4. With a fine liner, outline your word art. Now have fun embellishing the clothing! Erase the pencil lines.

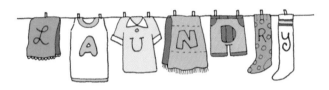

5. Add your favorite clothing colors!

6. Now it's your turn!

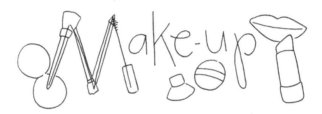

1. Write the word MAKE-UP with playful letters. For this word art, I added a drawing of lipstick and lips.

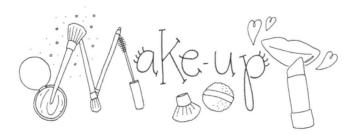

2. Form the letter M with make-up brushes and wands. You can also add other kinds of cosmetics or beauty products.

3. With a fine liner, outline your word art. Add more doodle details, like drawing eye lashes on the letters A and P, and surrounding the lips with a few hearts. Erase the pencil lines.

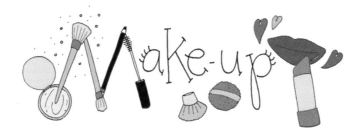

4. Color in your word art with your favorite cosmetic colors.

5. Now it's your turn!

. ACKNOWLEDGMENTS .

This book would not have been possible without the guidance of Jeannine Dillon, Lydia Anderson, and everyone at The Quarto Group. Thank you for believing in my abilities and giving my doodles a chance.

To all my wonderful subscribers and the people who watch my videos on my YouTube channel: Thank you for your never-ending support and appreciation of my art. I would never have reached this place if it weren't for you.

I would like to thank my family (in-laws and all), for giving me confidence and positive encouragement throughout my career as a doodle artist. They are always sharing my videos and spreading the word about my YouTube channel. Thank you for pushing me to do my best.

Thank you to my sister, Krissy, for sharing your ideas and advice on how I can improve as an artist. And to my brother, Alvin, who I know is too modest to admit that he is very proud of me.

To Kyle, Kara, Liam, Lily, and Jake: Thanks for being my source of happiness and inspiration.

To my parents: Thank you for your unconditional love. You never stopped believing in me.

To my husband who has been beside me throughout my journey: You were with me when I started scrapbooking. You never even complained when I hoarded stationery and art supplies. Thank you for helping me build my art studio and assemble all the furniture. You have been my number-one supporter from my very first video to my first book. I appreciate everything that you do for me.

Finally, I thank our Lord God for blessing me with this skill, these opportunities, and these lovely people surrounding me. I am grateful to Him for getting me through all the difficulties and challenges I have encountered in the course of making this book.

ABOUT THE AUTHOR

Sarah Alberto is a self-proclaimed doodle artist behind the YouTube channel Doodles by Sarah. She makes doodle tutorials of everyday things, as well as DIY cards and Doodle Letters. She lives in Sydney, Australia, with her husband, two children, and their cat.